TUNDRA SWANS

TEXT & PHOTOGRAPHS BY **BIANCA LAVIES**

DUTTON CHILDREN'S BOOKS
NEW YORK

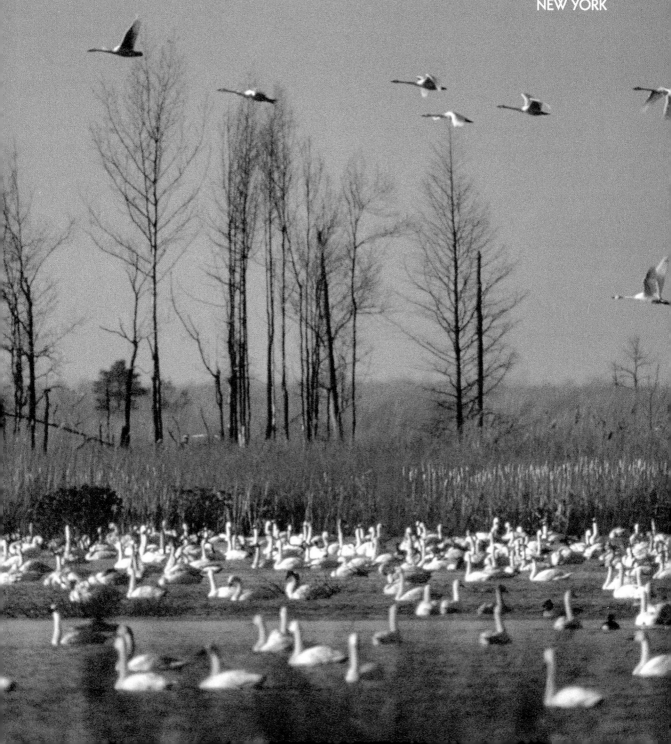

ACKNOWLEDGMENTS

For sharing time and knowledge,
the author wishes to thank:

Dr. William J. L. Sladen
Dr. Roland Limpert, the Chesapeake Wildlife Heritage
Jeanette W. Evans, research assistant

Library of Congress Cataloging-in-Publication Data
Lavies, Bianca.
 Tundra swans / text and photographs by Bianca Lavies.
 p. cm.
 Includes bibliographical references.
 ISBN 0-525-45273-7
 1. Tundra swans — Juvenile literature.
 [1. Tundra swan. 2. Swans.] I. title.
QL696.A52L38 1994
598.4'1 — dc20 94-26898 CIP AC

Published in the United States 1994 by Dutton Children's Books,
a division of Penguin Books USA Inc.
375 Hudson Street, New York, New York 10014

Designed by Frezzolini Severance Studio

Printed in Mexico First Edition
10 9 8 7 6 5 4 3 2 1

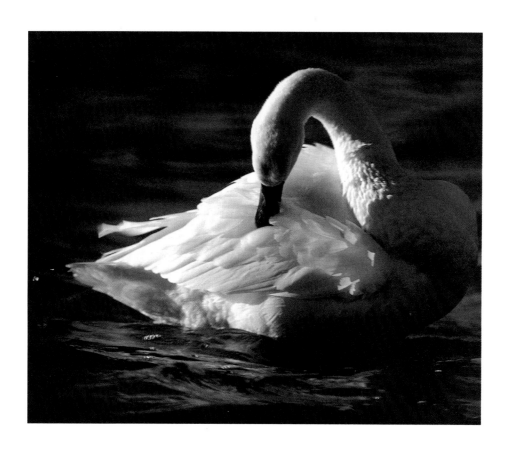

To my friends Marge and Pete Jackson,
who are visited each winter by the
magnificent tundra swans

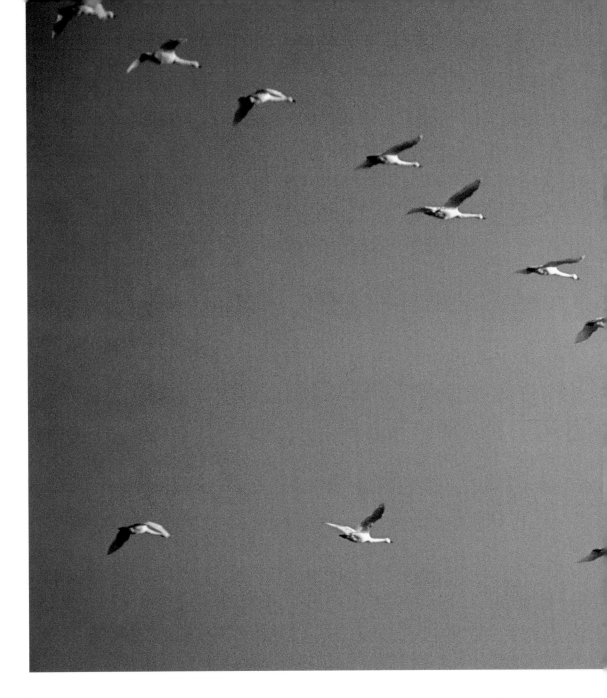

It is a crisp, cloudless day in September. Overhead, an eerie baying fills the sky. A flock of tundra swans is heading south. The birds cry out to each other as they wing their way from the Arctic Circle to the east coast of the United States. There, in the waters of Chesapeake Bay, they will spend the winter months.

Tundra swans get their name from their summer home—a frozen, treeless plain, or tundra, in northern Canada and Alaska. Tundra swans are also called whistling swans, but not because of their cry, which sounds more like howling. They probably earned the name from the

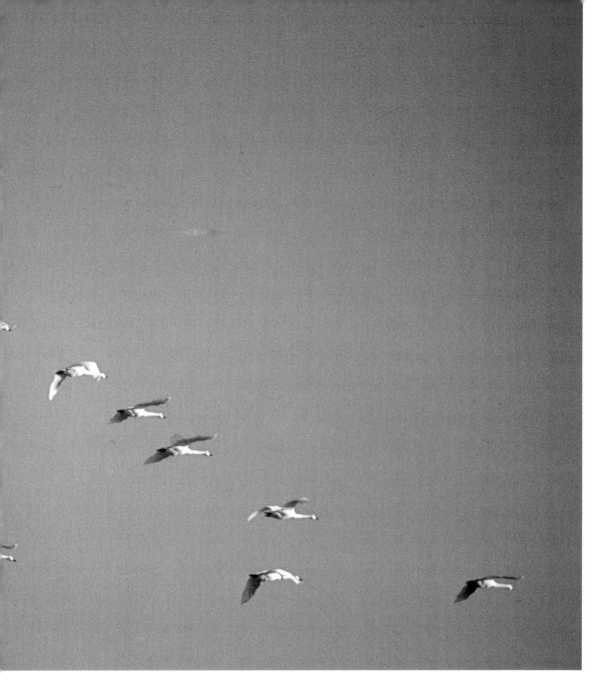

noise the wind makes whistling through their feathers as they fly.

Tundra swans travel at an altitude of from two thousand to eight thousand feet, above any rough, turbulent winds. Their V formation also makes flying easier. Each bird blocks some of the strong air currents for the bird traveling behind it. Because the lead swan is not shielded from the wind, it occasionally drops back in the formation to rest.

The flying formation pictured here is made up of several swan families, voyaging together more than four thousand miles to reach their winter home.

The sooty-gray bird in the photo at right is a young tundra swan, or cygnet. It is flying between its parents. The young bird hatched from one of six creamy-white eggs that its mother laid in June. In less than three months the cygnet has matured from a six-ounce ball of wet down to an almost full-grown, ten-pound juvenile swan. During those summer months, there were many hours of daylight in which to search for food. From June until the beginning of August, the sun never sets over much of the Arctic tundra. While the cygnet looked for food, its parents guarded it from predators such as eagles, wolves, and foxes.

This is the cygnet's first trip south. The family bond is strong, because swans usually mate for life. Cygnets do not leave their parents until they have flown with them on the autumn migration south and the spring migration north. It is thought that in this way the young swans learn the routes from the older ones.

Swan families migrate in small, related groups of from ten to one hundred birds. They follow the same routes, called flyways, each year. For the autumn migration, about half of the North American tundra-swan population flies from western Alaska to spend the winter

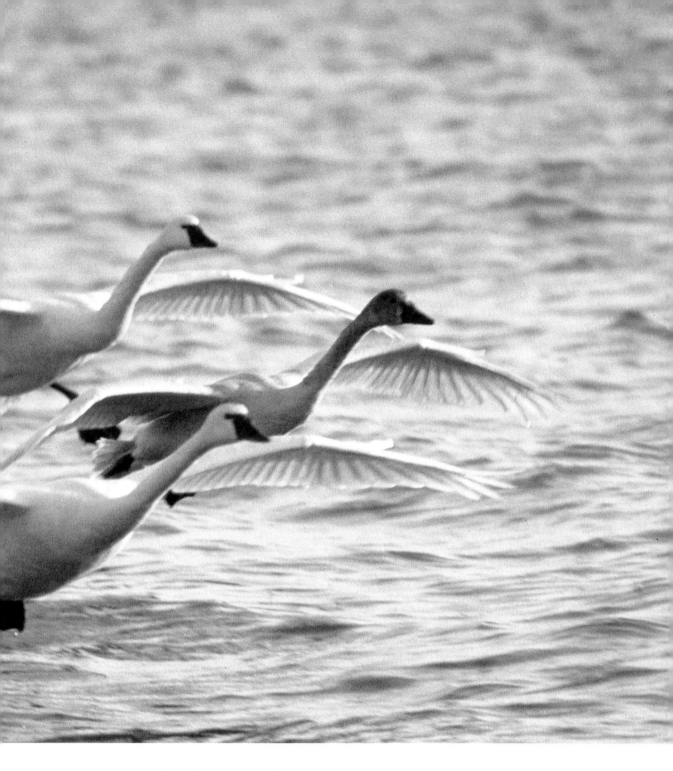

along the Pacific coast of British Columbia and the United States. The rest head southeast from Alaska and Canada to the mid-Atlantic states. These birds have the longest journey. And they usually fly the final leg of it, from North Dakota to the East Coast, without stopping. Strong air currents out of the northwest help them cover this thousand-mile distance in just twenty-four hours!

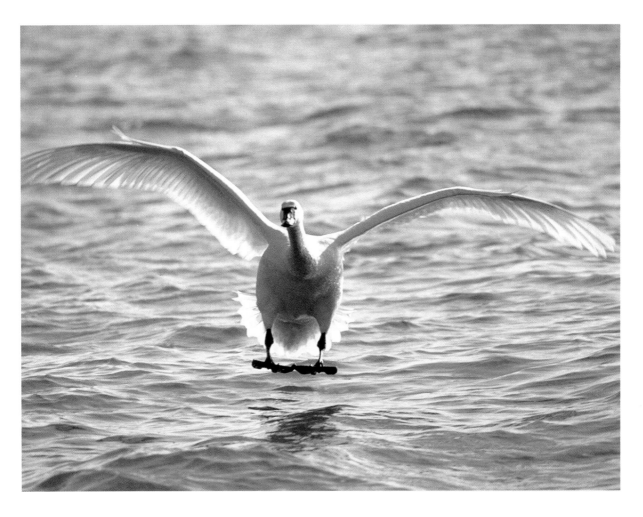

The tundra swan is one of eight kinds of swans in the world. It is among the largest of the flying birds. Adult tundra swans typically weigh from eighteen to twenty pounds and have a wingspan of seven feet. Their size and body structure make them powerful fliers. They can wing along at a speed of up to fifty miles per hour, almost as fast as a car goes on a highway.

After a long journey, the tundra swan in the picture above is about to touch down on Chesapeake Bay. The bay stretches from the northern border of Maryland to southern Virginia. It has over forty-five hundred miles of shoreline to attract migrating birds. More than one million waterfowl spend the winter in its abundant coves, and another million water birds stop there on their way farther south.

A tundra swan lands facing into the wind, just as a plane does. The wind helps to slow it down. It uses its outstretched wings as brakes by tilting them backward slightly so that they cup the air. Black webbed feet spread wide and hit the water, slowing the bird to a stop.

Taking off for another part of the bay, the swan below faces into the wind again, this time using it for lift. The bird hoists its heavy body out of the water by beating the air with its powerful wings. Its big feet slap against the surface as it runs across the water to gain flying speed. Flapping its wings with rapid, shallow strokes, the swan rises into the air.

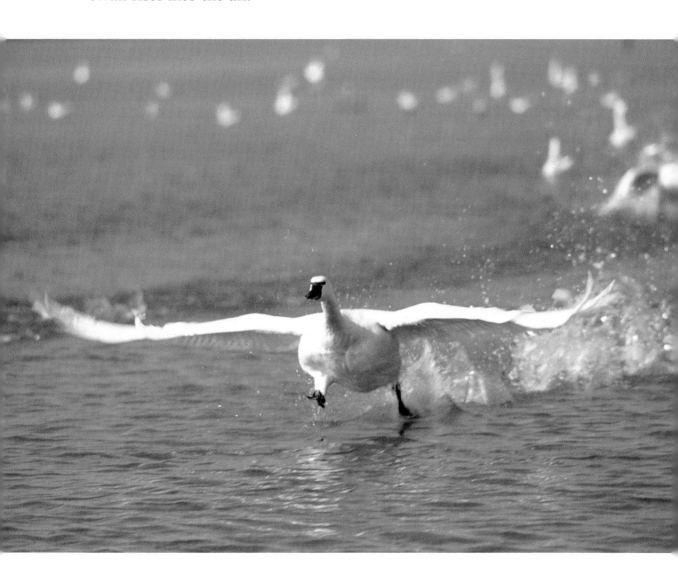

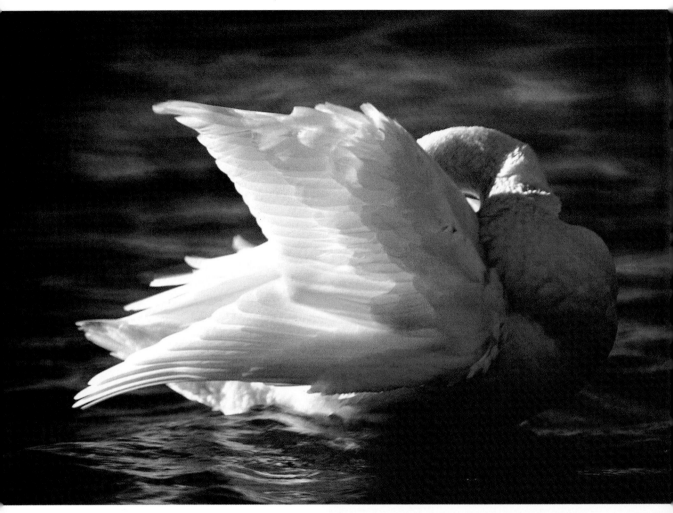

These swans are caring for their feathers by bathing and preening. Feathers are important for flying because they give shape to the wings and form a smooth, wide surface that pushes against the air to lift the bird. Feathers also act as insulation from the cold.

To bathe, the swans merely splash their feathers with water.

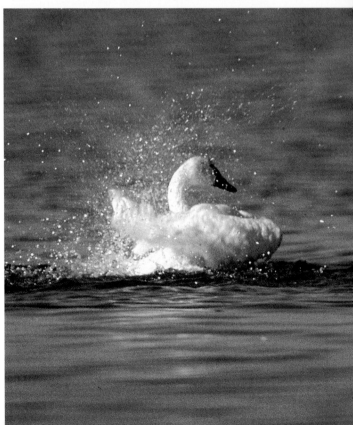

Then the preening begins. They reach back with their bills and nibble an oil-secreting gland at the base of their tails. Once the oil is on their bills, they use their heads and long, flexible necks to spread the slick substance all over their outer, or contour, feathers. The oil coating prevents water from reaching a thick inner layer of soft down feathers. It is this layer that keeps the swans warm. As the coat of oil is applied, air becomes trapped among the down feathers. It is warmed by the swans' own bodies and insulates them from the cold temperatures of the water and the wind.

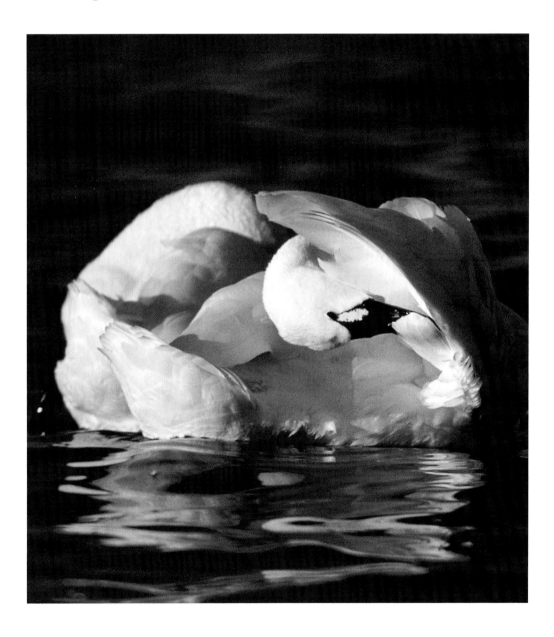

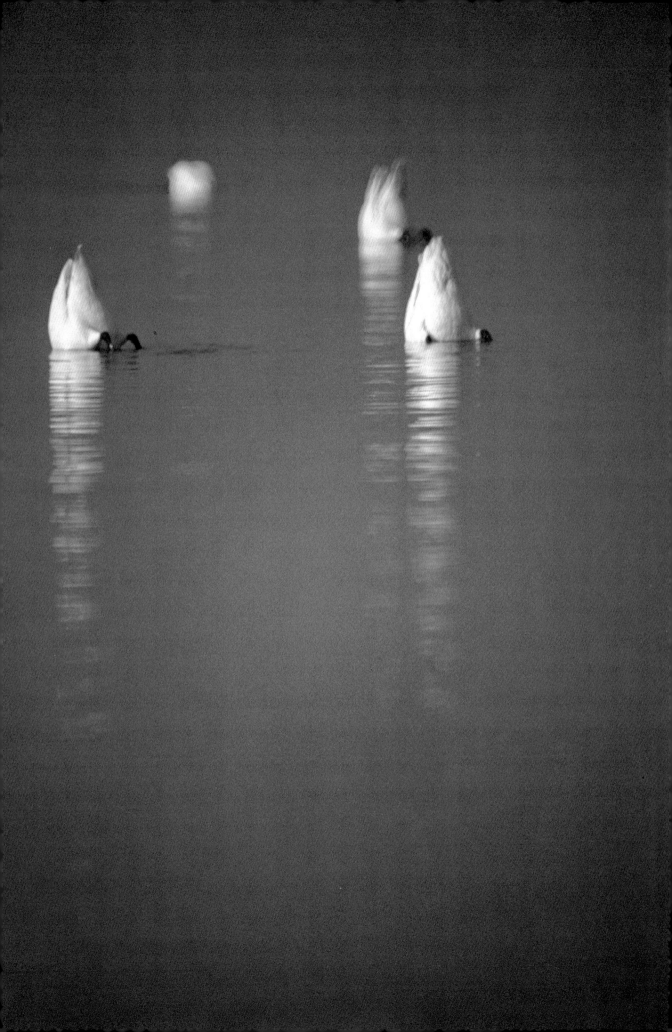

Tundra swans spend much of the winter foraging for food. These swans have found underwater plants to eat. They tip forward until just their tail feathers show above the surface. Their long necks reach down to the plant roots and tubers at the water's bottom. If the swans are feeding in shallow water, they do not need to upend themselves. They keep their bodies erect and dip just their heads and necks under until their chins rest on the bottom. Submerged this way for ten to twenty seconds at a time, they yank up the plants with their strong, rough-edged bills.

Aquatic grasses are the swans' main diet, but they also hunt for insects and small mollusks like clams. The swans' messy eating habits help other life in the bay survive. Small ducks that cannot reach the water's bottom dine on the grassy debris churned up by the foraging swans. Their foraging also disperses seeds, causing more plants to grow.

Recently, sewage and fertilizers from local farms and communities have washed into Chesapeake Bay, clouding the water and causing tiny, floating plants called algae to grow on the surface. The algae block the sunlight that the submerged grasses need to survive.

Tundra swans have adapted to this loss of their main food by scavenging corn from nearby fields. But swans are aquatic birds. They are not as agile on land and so are more vulnerable to hunters and animal predators.

Hunting tundra swans is legal in many states. In Virginia, where about six thousand tundra swans spend the winter, the hunting season is particularly upsetting to swan watchers. The birds arrive exhausted from their four-thousand-mile autumn migration, and hunters are allowed to shoot them as they land. Scientists and bird conservationists worry about the swan population's ability to survive legalized hunting and the loss of its natural diet and habitat.

Dr. William Sladen, pictured below, has been studying tundra swans for more than twenty-five years. He is particularly interested in learning more about their migration. To keep track of individual swans and to make sure they can be recognized wherever they are spotted, Dr. Sladen works with a team of volunteers and scientists from Johns Hopkins University to capture the birds and give them identifying bands.

The team uses corn to lure a flock of tundra swans to a certain place on land. Then, with the help of experts from the U.S. Fish and Wildlife Service, they set off rockets that shoot a 130-foot net over the unsuspecting birds. Dr. Sladen and his crew run to make sure the net does not harm any swans.

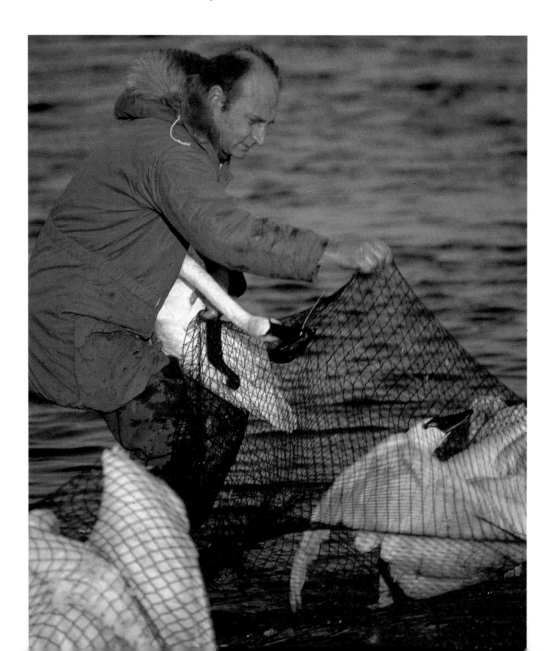

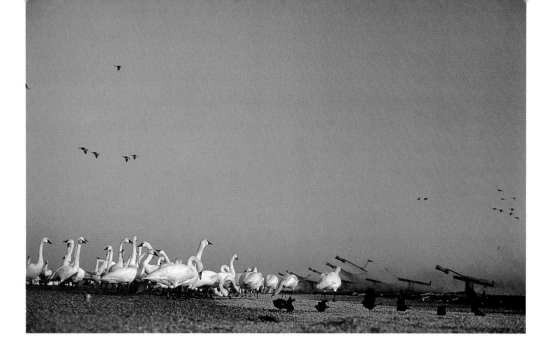

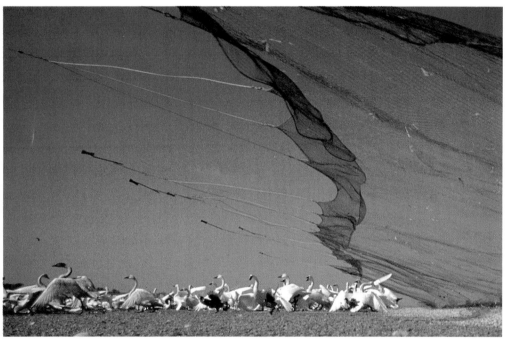

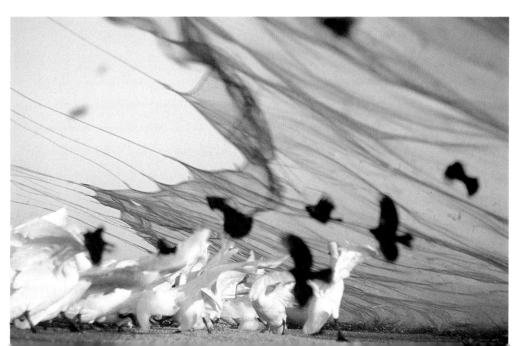

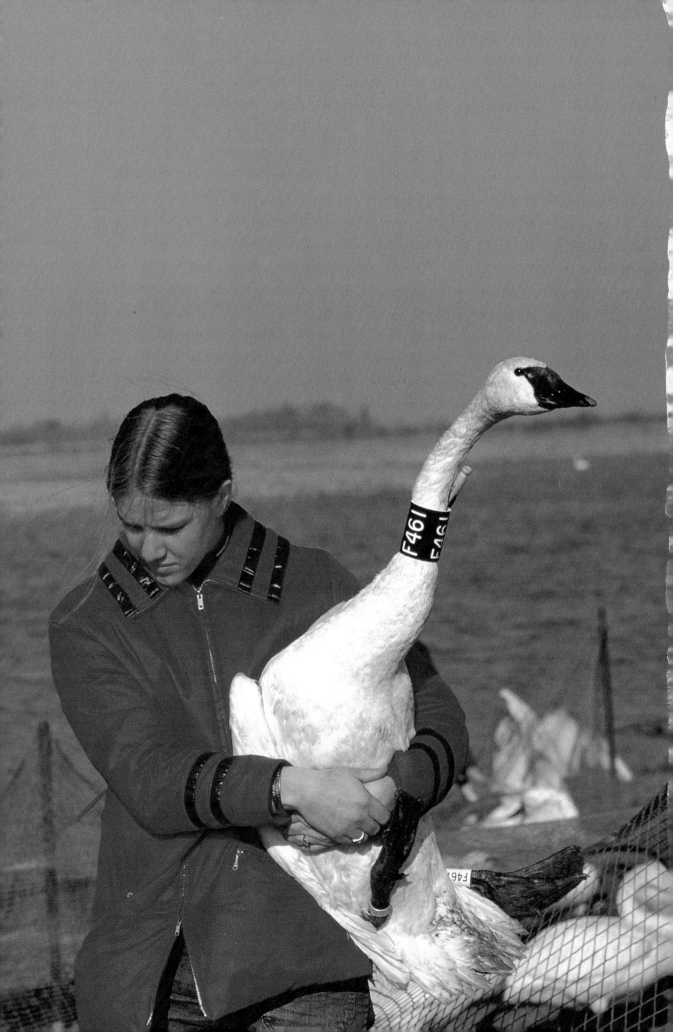

One at a time, the swans are carried to a table where they are fitted with lightweight plastic collars, each with a different number printed on it. These bands do not get in the swans' way when they fly or dip underwater for food. By numbering the swans, scientists are able to tell them apart with certainty. From a distance, a swan's number can be read through a telescope or binoculars. Then its location can be added to the individual history of the bird.

The helper in the picture at left is holding a swan close so that its freshly glued collar, held shut with a clothespin, has time to dry.

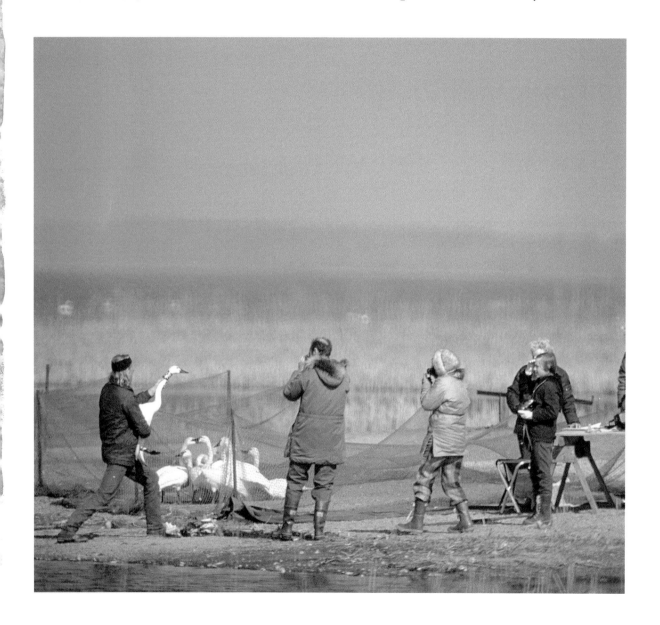

A wild tundra swan becomes completely docile when it is held, so the young people on Dr. Sladen's team enjoy assisting with the banding process. The tundra swan in the photograph below sits very quietly as a volunteer holds it in the harness in which it will be weighed.

Scientists describe the swans' response to contact as "playing possum." Like possums, the swans sometimes react to danger by pretending to be sick or dead so that their predators will lose interest and leave them alone.

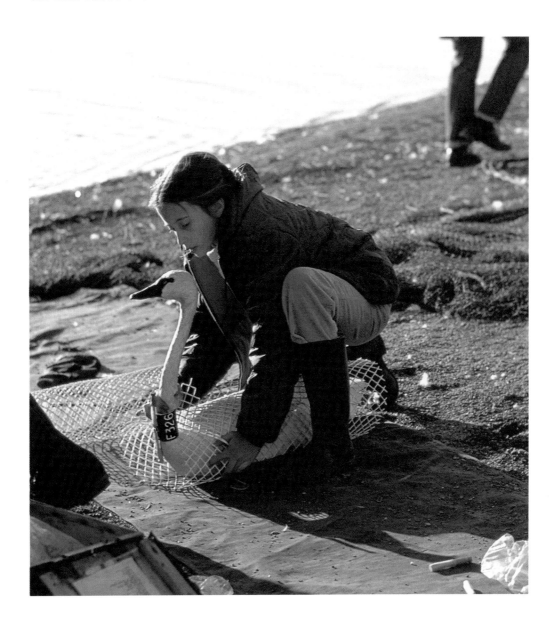

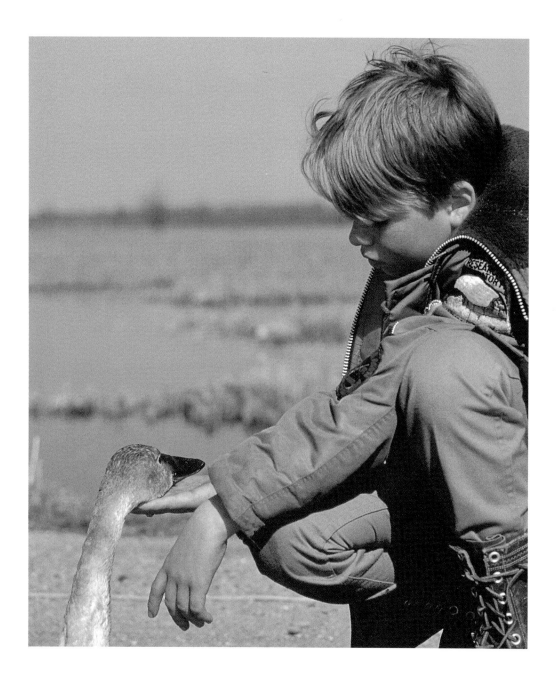

This cygnet is also waiting in a harness to be weighed. Another volunteer cups the young swan's head in his hand and whispers words of comfort.

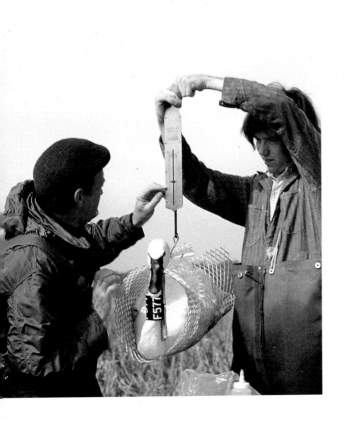

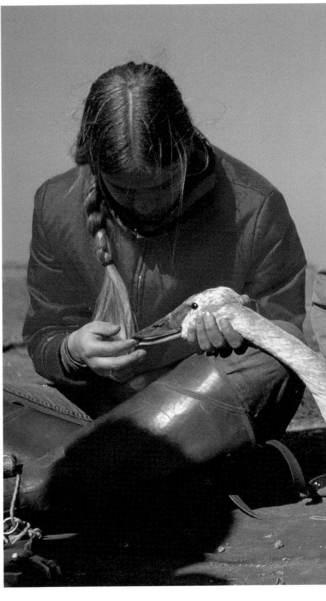

The harness is attached to a portable scale; then the bird is simply lifted in the air, and its weight is registered. Once recorded, the weight becomes part of the swan's permanent history.

Each bird is also given a numbered, metal leg band in case the collar on its neck falls off. As Dr. Sladen puts a band on one of the birds, he tells his volunteers about the importance of the tundra swan.

He explains that the tundra swan is one of only two kinds of swans that are native to North America. The other is the trumpeter swan. The mute swan, the type usually seen in parks, is not a native bird but a domesticated European species.

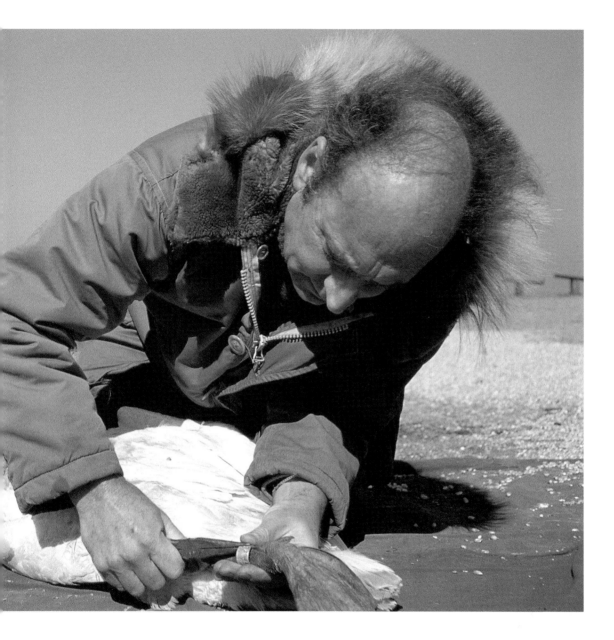

Trumpeter swans are larger than tundra swans. And they are much rarer; there are only about sixteen thousand of them left in North America. The trumpeters were driven almost to extinction by hunting and loss of habitat. Many of those that survive live in protected areas. Tundra swans could become just as rare and endangered as trumpeter swans unless people learn to respect them and their environment.

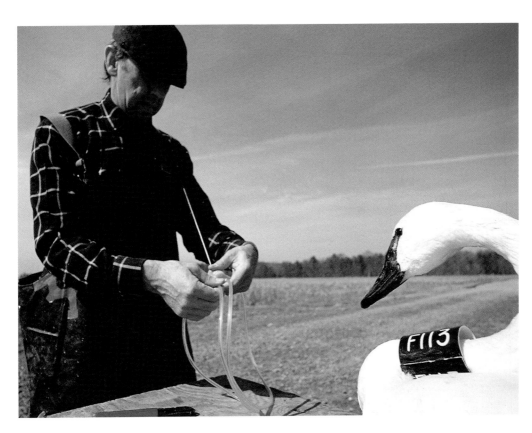

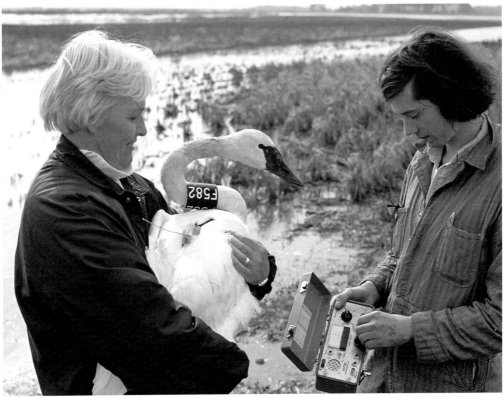

A tragic accident in 1962 emphasized the need to learn more about tundra swans and their migratory routes. A flock of swans flying over Ellicott City, Maryland, collided with a small airplane. The plane crashed, and all seventeen people onboard were killed.

To discover the exact routes that the swans take each year, Dr. Sladen and his team decided to follow the birds during their spring migration from Maryland to the Arctic. They fitted the swans with tiny radio transmitters to make tracking the birds easier. These three-ounce devices were developed especially for the project by team member William Cochran. They could be comfortably harnessed to the swans' backs with tubing

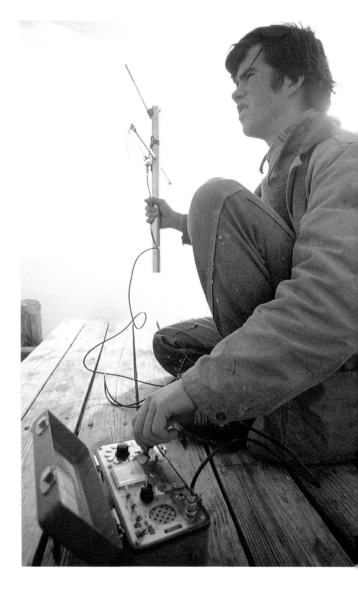

like that shown at the top of the opposite page. The transmitters did not impede the swans' flight, and they were designed to fall off safely after three months. Each bird's transmitter broadcast a different radio signal that could be picked up by Dr. Sladen's team on a receiver like the one pictured above.

In the photo at the bottom of the opposite page, two volunteers are testing a swan's transmitter to make sure its signal is strong. The swans are ready to be released and tracked. The team will follow them twenty-four hours a day at a range of from five to one hundred miles.

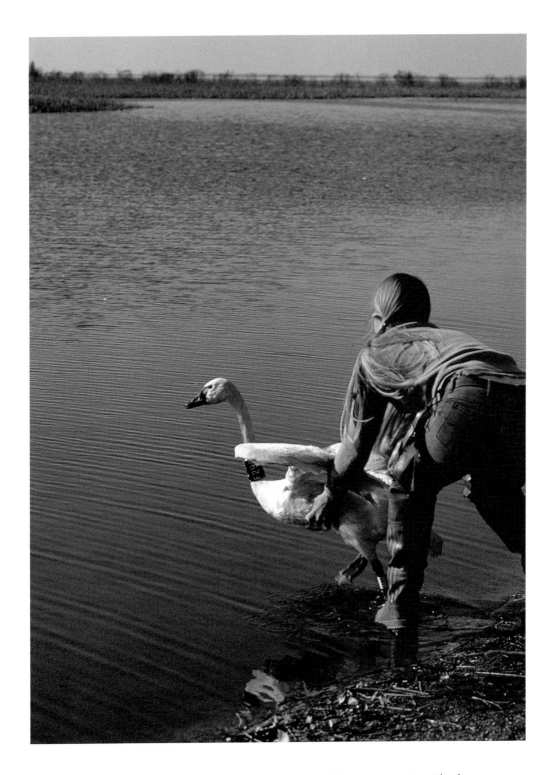

This volunteer is releasing a swan into the water. Dr. Sladen's team will now wait for the swans to take off from Chesapeake Bay on the first part of their spring migration north to the Arctic tundra.

Scientists and bird-watchers in the United States and Canada have been alerted to look out for banded swans and to report any sightings to their country's wildlife authorities.

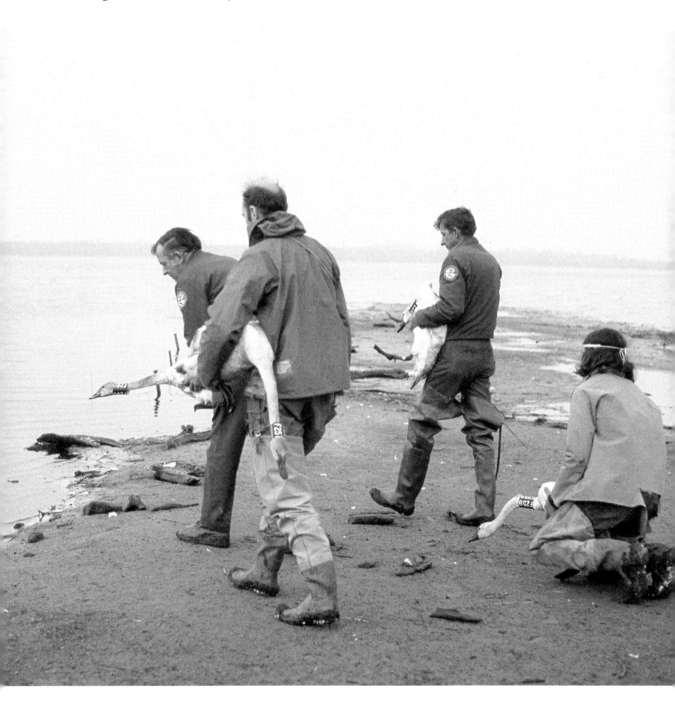

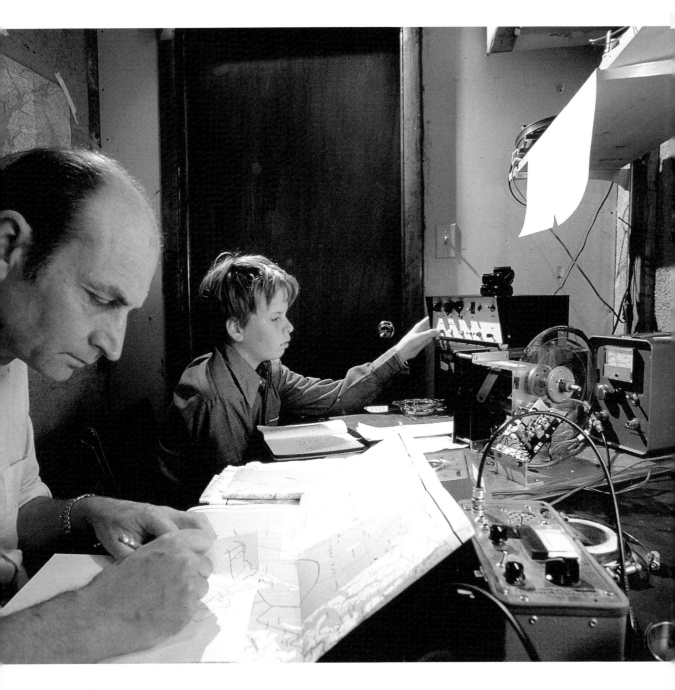

But Dr. Sladen's team is also preparing to follow the radio swans.
A permanent tracking station with radio receivers has been set up
on the western shore of Chesapeake Bay near Annapolis, Maryland.
Dr. Sladen, pictured above, waits in this station with his son Hugh
for the signal that the radio swans have taken off from the bay. He
and his team are ready to follow them with portable receivers that
can be operated from a van or even from a plane.

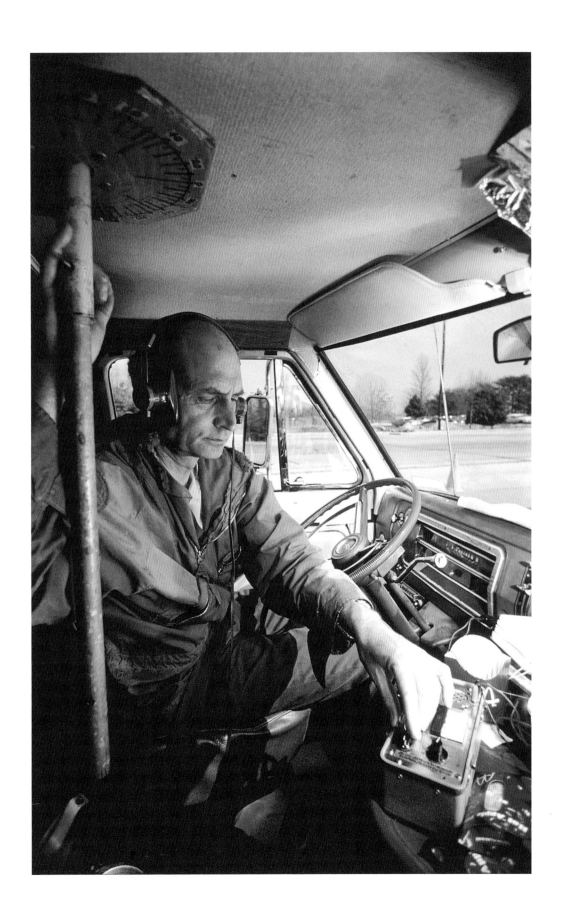

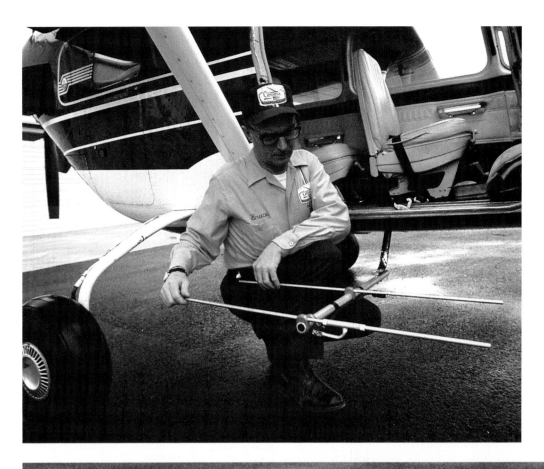

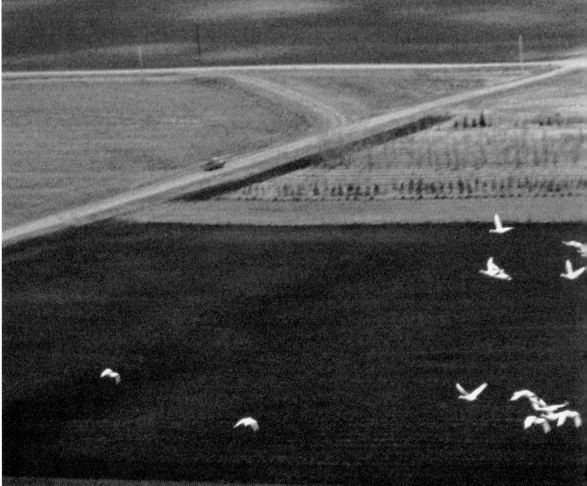

Here a pilot is installing an antenna on his plane to pick up the swans' signals. When the swans take off in mid-March, so do the scientists. Listening on headphones inside the plane, a researcher can recognize an individual swan by the particular beep of its transmitter. The loudness or softness of the signal tells him how near or far away the swan is. A loud beep can be as close as five miles; a faint beep may come from as great a distance as one hundred miles. The researcher gives the pilot the directions, and soon they catch up with the swan. In the picture below, a flock of tundra swans can be seen flying beneath the plane.

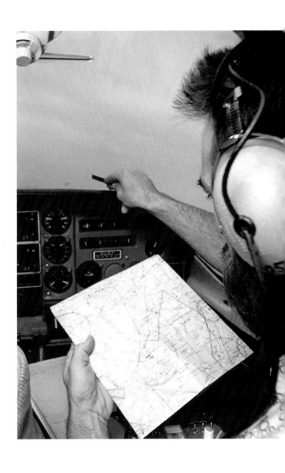

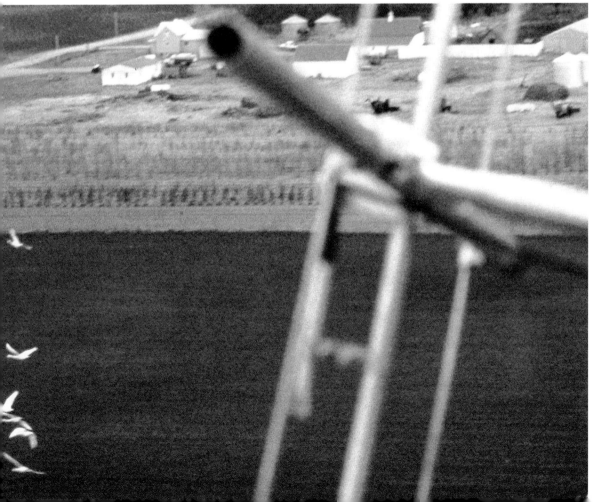

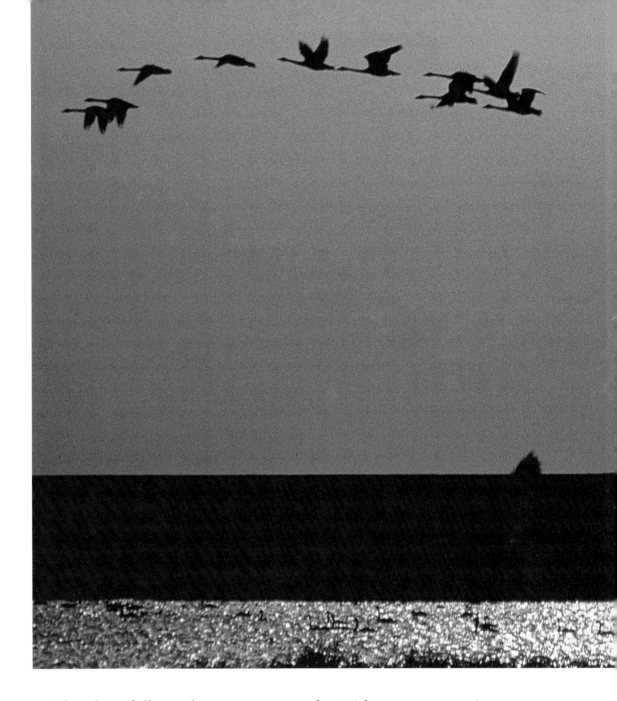

The plane follows the swans across the Midwestern states into Canada. Although the plane must land often to refuel, the feathered travelers rarely seem to tire. Winging their way day and night, the tundra swans make short stops on the Great Lakes, the upper Mississippi River, and the prairies of Canada. Sometimes the swans fly as many as six hundred and forty miles in thirty hours with just one stop to rest and eat. And on the way north they do not have the help of the northwest tailwind that propelled them southward on their autumn migration.

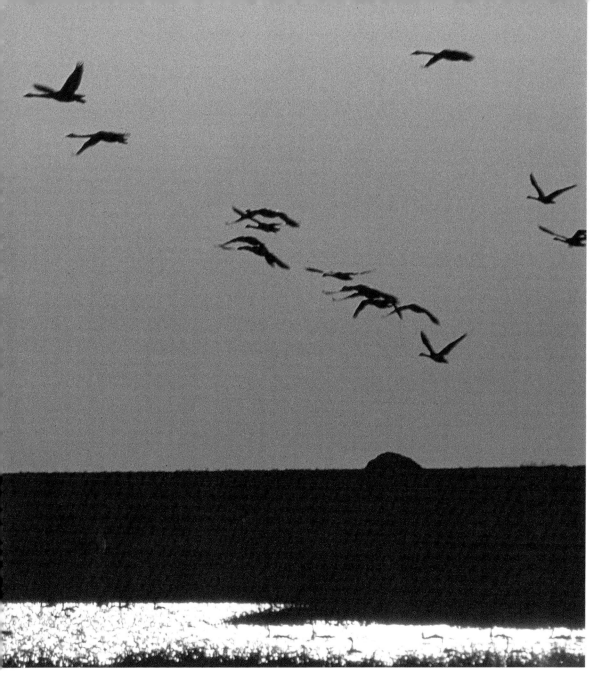

When the swans arrive on the tundra, the parents finally leave their cygnets and continue back to their nesting sites alone. The cygnets and young adult swans spend the summer away from the nesting areas so that they do not compete with the breeding pairs for food. They themselves will not mate until they are three to four years old.

The Arctic summer is short—just three or four months. The swan parents get busy raising another brood. There is much to be done. A new generation of tundra swans must be ready to make the long journey south, across a continent, come September.

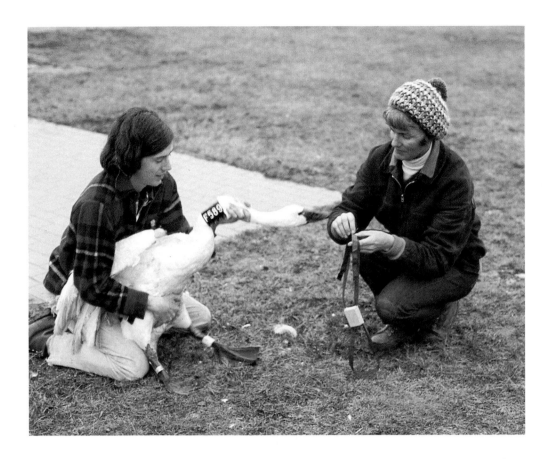

Bianca Lavies, shown here repairing a swan's radio harness, enjoyed her many adventures as she traveled with Dr. Sladen and his tracking crew.

"I would get up at four in the morning to photograph swans taking off at sunrise from a deserted North Dakota lake," she recalls. "One morning when I returned to the hotel, everyone had gone. A message told me that Bill Sladen and his group had left in the middle of the night to follow a swan. I had no idea where they were until I got another message. Then I drove one hundred and three miles north to a small motel in a little town in the middle of nowhere. I did not need the number of their room. There was only one room with a big black wire leading into its window from an antenna on the roof! There they were again, with all their electronic gear spread out over the floor. Bill Sladen was listening to the radio. The others had left by car to look for the swan on a nearby lake.

"As I drove to the lake, I was the first to spot the swan. It was the one I had photographed a month earlier being banded and harnessed at the Blackwater National Wildlife Refuge in Cambridge, Maryland, more than fourteen hundred miles away!"